fa

the poc

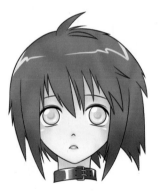

Yishan Li

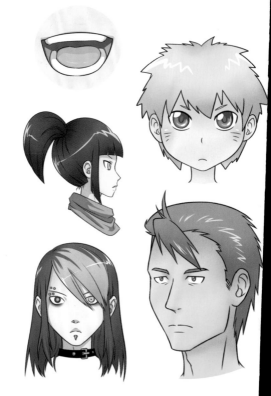

faces & hair

the pocket reference to drawing manga
Yishan Li

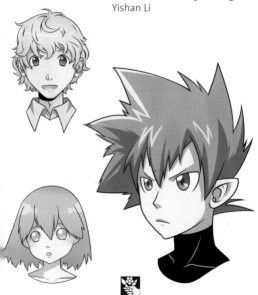

Search Press

First published in Great Britain 2010 by
Search Press Limited
Wellwood, North Farm Road,
Tunbridge Wells, Kent TN2 3DR
Reprinted 2012

Created and conceived by
Axis Publishing Limited
8c Accommodation Road
London NW11 8ED
www.axispublishing.co.uk

Creative Director: Siân Keogh
Editor: Anna Southgate
Art Director: Sean Keogh
Production Manager: Bili Books

ISBN: 978-1-84448-523-9

contents

Introduction

Manga has become a popular art form across the globe. Originating in Japan, the term is the Japanese word for 'comic', as it was in Japanese comic strips that such characters were first seen.

manga style

The huge popularity of manga has much to do with the content of the comic-strip stories. Invariably this involves a moralistic tale of good versus evil, in which good inevitably claims victory. Along the way, characters face challenges and encounter strange beings that look set to obstruct their goals.

What stands out about manga art is the appearance of the 'human' looking characters. There is often a great deal of ambiguity here; with

super-skinny girls and pretty boys
making it difficult, sometimes, to
determine gender.

the manga face

Although drawn to familiar scale
and proportion, manga faces are
generally simplified forms, rendered
by using the minimum of
lines and flat colour.
The mouth may be
a single line, the
nose just a curve in
the middle of the
face. In most cases
the eyes dominate,

Facial features are kept to
the minimum, allowing
the eyes to become the
dominant feature.

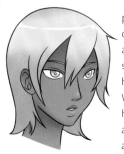

particularly in younger characters, where they are exaggerated, sometimes taking up half of the face. When it comes to the hair, spiky tresses and asymmetrical fringes abound, and there are no rules when it comes to colour.

your manga art

In order to draw your own manga characters, it is a good idea to get to grips with the key characteristics outlined above, and that is where this book comes in. Step by step, the instructions on the following pages show you how to draw convincing manga faces and hair, from the very first rough sketch to finished artwork. You will learn how to draw male and female faces of all ages in

a range of different poses, and with a variety of different hairstyles. Each of the main characters has instructions for drawing them from different views, making sure you get proportion and perspective right. Examples of the main facial features show how they vary from male to female, adult to child, allowing you to draw every character in your imagination.

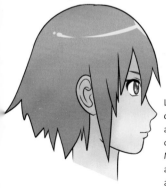

Long fringes are common in manga art, often covering one of the eyes. Many hairstyles are asymmetrical and spiky.

materials and equipment

In order to create your own manga art, it is a good idea to invest in a range of materials and equipment. The basics include paper for sketches and finished artworks, pencils and inking pens for drawing and colour pencils, markers or paints for finishing off. There are also a handful of drawing aids that will help produce more professional results.

drawing

Every manga character must start with a pencil sketch – this is essential. You need to build each figure gradually, starting with a structural guide and adding physical features, then hair, in layers. The best way to do this effectively is by using a pencil.

pencils

You can use a traditional graphite pencil or a mechanical one according to preference. The advantages of the latter are that it comes in different widths and does not need sharpening. Both sorts are available in a range of hard leads (1H to 6H) or soft leads (1B to 6B); the higher the number in each case, the harder or softer the pencil. An HB pencil is halfway between the two ranges and will give you accurate hand-drawn lines. For freer, looser sketches, opt for something softer – say a 2B lead. Some of the sketches in this book are drawn using a blue lead. This is particularly useful if you intend to produce your artworks digitally, as blue does not show up when photocopied or scanned. If you opt for a traditional graphite pencil, you will also need a pencil sharpener.

An eraser or putty eraser is an essential tool. Use it to remove and correct unwanted lines or to white-out those areas that need highlights. Choose a good-quality eraser that will not smudge your work.

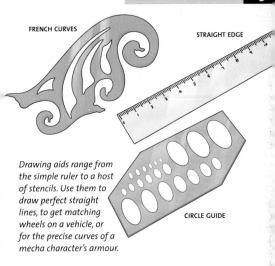

FRENCH CURVES

STRAIGHT EDGE

CIRCLE GUIDE

Drawing aids range from the simple ruler to a host of stencils. Use them to draw perfect straight lines, to get matching wheels on a vehicle, or for the precise curves of a mecha character's armour.

drawing aids and guides

The tips in this book show you how to draw convincing manga characters from scratch by hand. There may be times, however, when drawing by hand proves a little too difficult. Say your composition features a futuristic city scape; you might want to use a ruler to render the straight edges of the buildings more accurately. The same could be true if you wanted to draw more precise geometric shapes – a true circle for the sun, for example.

inking and colouring

Once you have drawn your manga character in pencil, you can start to add colour. This is where you can really let your imagination run free. There are numerous art materials available for inking and colouring and it pays to find out which ones suit you best.

inking

A good manga character relies on having a crisp, clean, solid black outline and the best way to achieve this is by using ink. You have two choices here. First is the more traditional technique, using pen and ink. This involves a nib with an ink cartridge, which you mount in a pen holder. The benefit of using this method is that you can vary the thickness of the strokes you draw, depending on how much pressure you apply as you work. You also tend to get a high-quality ink. The alternative to using pen and ink is the felt-tipped drawing pen, which comes in a range of widths. A thin-nibbed pen (0.5mm) is best, but it is also a good idea to have a medium-nibbed pen (0.8mm) for more solid blocks of ink. Whichever option you go for, make sure the ink is quick-drying and/or waterproof so that it does not run or smudge as you work.

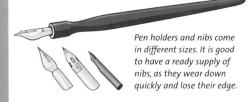

Pen holders and nibs come in different sizes. It is good to have a ready supply of nibs, as they wear down quickly and lose their edge.

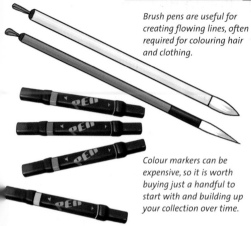

Brush pens are useful for creating flowing lines, often required for colouring hair and clothing.

Colour markers can be expensive, so it is worth buying just a handful to start with and building up your collection over time.

colouring

There are various options available to you when it comes to colouring your work. The most popular method is to use marker pens. These are fast-drying and available in many colours. You can use them to build up layers of colour, which really helps when it comes to creating shading in, say, hair or clothing. You can also use colour pencils and paints very effectively (gouache or watercolour). Colour pencils and watercolours are probably the most effective media for building up areas of tone – say for skin – and also for blending colours here and there. White gouache is very useful for creating highlights and is best applied with a brush.

papers

It is difficult to imagine that you will have the perfect idea for a character every time you want to draw a manga scenario. These need to be worked at – not just in terms of appearance – but also in terms of personality. It is a good idea, therefore, to have a sketchbook to hand so that you can try out different ideas. Tracing paper is best for this, as its smooth surface allows you to sketch more freely. You can also erase unwanted lines several times over without tearing the paper. A recommended weight for tracing paper is 90gsm.

Having sketched out a few ideas you will want to start on a proper composition, where you move from pencil outline to inked drawing to finished coloured art. If you are tracing over a sketch you have already made, it is best to use paper that is only slightly opaque, say 60gsm. In order to stop your colours bleeding as you work, it is important that you buy 'marker' or 'layout' paper. Both of these are good at holding colour without it running over your inked lines and blurring the edges. 'Drawing' paper is your best option if you are using just coloured pencils with the inked outline, while watercolour paper is, of course, ideal for painting with watercolour – a heavyweight paper will hold wet paint and colour marker well. You also have a choice of textures here.

It is always best to allow space around the edge of your composition, to make sure that the illustration will fill the frame.

using a computer

The focus of this book is in learning how to draw and colour manga characters by hand. Gradually, by practising the steps over and again you will find that your sketches come easily and the more difficult features, such as hands, feet and eyes, begin to look more convincing. Once that happens, you will be confident enough to expand on the range of characters you draw. You might even begin to compose cartoon strips of your own or, at the very least, draw compositions in which several characters interact with each other – such as a battle scene.

Once you reach this stage, you might find it useful to start using a computer alongside your regular art materials. Used with a software program, like Adobe Photoshop, you can colour scanned-in sketches quickly and easily. You will also have a much wider range of colours to use and can experiment at will.

Any home computer can be used for colouring your manga sketches in order to produce finished art.

You can input a drawing straight into a computer program by using a graphics tablet and pen. The tablet plugs into your computer, much like a keyboard or mouse.

Moving one step further, a computer can save you a lot of time and energy when it comes to producing comic strips. Most software programs enable you to build a picture in layers. This means that you could have a general background layer – say a mountainous landscape – that always stays the same, plus a number of subsequent layers on which you can build your story. For example, you could use one layer for activity that takes place in the sky and another layer for activity that takes place on the ground. This means that you can create numerous frames simply by making changes to one layer, while leaving the others as they are. There is still a lot of work involved, but working this way does save you from having to draw the entire frame from scratch each time.

Of course, following this path means that you must invest in a computer if you don't already have one. You will also need a scanner and the relevant software. All of this can be expensive and it is worth getting your hand-drawn sketches up to a fairly accomplished level before investing too much money.

good bone structure

It is important to have a basic grasp of the structure of the human head. All manga faces start from here.

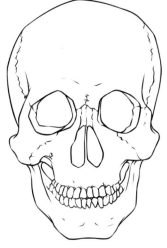

Looking at the human skull straight on, it can be divided, roughly, into five equal portions. The forehead makes up two-fifths, with the eyes and nose making up another two-fifths, and the mouth and chin making up the final fifth. You need to keep these proportions in mind when drawing. Note, also, the size of the eye sockets, the protruding cheekbones, and the narrowing of the head from top to bottom.

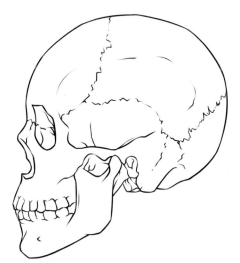

Viewed from the side, it is possible to see where the facial features are positioned in relation to the rest of the skull – not forgetting the proportions when looking from straight on. For example the eyes fall approximately two-fifths of the way down the face, while the ear sits pretty much centrally, and the mouth and jaw line fall lower than the back of the skull. The shape of the skull is generally oval.

face shapes

While all faces tend to have the same features, generally in the same proportions, they can vary tremendously.

A basic face for a youthful male or female – in manga many characters are quite androgynous. This is close to the human equivalent with a smooth chin and cheeks. The facial features (eyes, mouth) are not exaggerated here, as they are in much manga art.

A basic face for a childlike character. The face is slightly shorter than the previous example, and the chin more pointed. Note that the eyes are bigger, which tends to be the case with children. Other facial features are very simple, to draw attention to this.

▶▶

face shapes continued

This more exaggerated face, is characteristic of the typical manga male or female. Features are becoming more pronounced – the forehead is rounder, the chin much more pointed. The eyes are large and very much the central feature.

This type of face is more typically associated with mature male or female manga characters. It is generally longer, with thinner cheeks and a pointy chin.

This is the more rounded face of the manga chibi character. Again, the eyes are exaggerated and have become the focal point of the face. This, and the rounded shape of the head, is what gives the chibi character its cuteness.

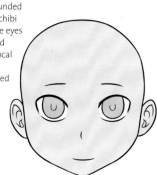

face shapes side view

These five face shapes correspond to the straight-on versions seen on pages 22–25, now seen from the side.

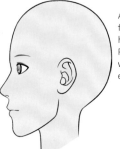

A basic, youthful male or female head, close to the human equivalent. Proportions are normal – with regular shapes for the eyes, nose, ear and chin.

The basic head of a child or teenager. The profile is more manga here, with pointed nose and chin. Note that the eyes are bigger, too.

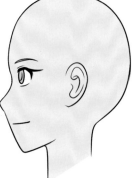

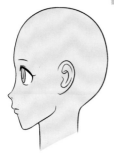

The head of a manga adult. The eyes are large and very much the central feature, while the nose, mouth and chin are less pronounced.

The smaller, more rounded head of the manga chibi. The profile is simplified, with nose, mouth and chin drawn in one sweep. The eyes are huge.

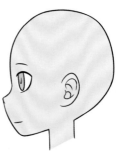

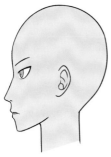

The head of a mature male or female manga character. The profile is longer than average and very angular.

the face and age

The general shape of the head and the profile of the face can be used to show the age of a manga character.

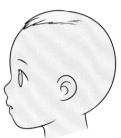

A very young character should have a rounded head. The profile is soft and full, with smooth lines. The nose and ears are simple shapes, while the eyes are big and round.

The head of child or teenager becomes more shapely. Lines are still smooth, but the profile is generally more angular.

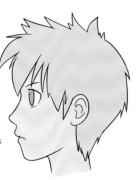

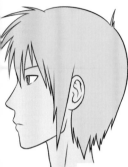

The head of the adult manga is leaner and longer. The nose and chin are more pointed and the eyes are smaller than those of a younger character.

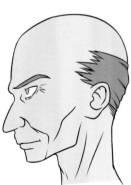

Older manga characters tend to have sharper lines, and more of them to give the impression of wrinkled skin. The bony structure of the skull is more evident.

▶▶

the face and age continued

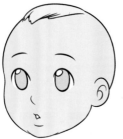

A three-quarter view of the youngest character. Lines are smooth and rounded. The big, oval eyes are the central feature. There is very little hair.

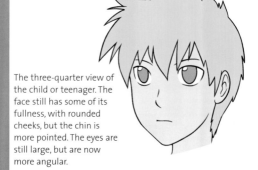

The three-quarter view of the child or teenager. The face still has some of its fullness, with rounded cheeks, but the chin is more pointed. The eyes are still large, but are now more angular.

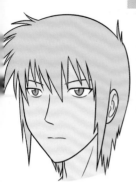

The three-quarter view of the adult manga character. Facial features are closest to those of a human face. The face is generally longer and leaner, however.

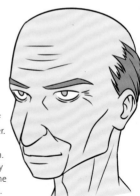

The three-quarter view of the older manga character. Again, facial features are close to those of a human. Heavy lines help to convey the more pronounced bone structure of an older man.

basic face shape female

You can draw a basic female face in four easy steps. The guidelines can help to position the facial features later on.

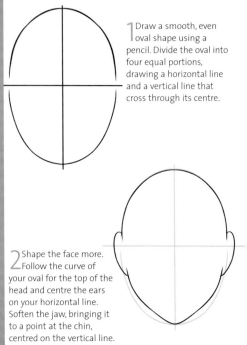

1 Draw a smooth, even oval shape using a pencil. Divide the oval into four equal portions, drawing a horizontal line and a vertical line that cross through its centre.

2 Shape the face more. Follow the curve of your oval for the top of the head and centre the ears on your horizontal line. Soften the jaw, bringing it to a point at the chin, centred on the vertical line.

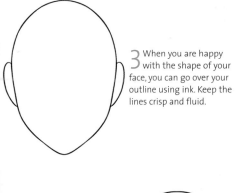

3 When you are happy with the shape of your face, you can go over your outline using ink. Keep the lines crisp and fluid.

4 Erase any unwanted pencil lines and give your face a flat colour on which to build your character's facial features.

basic face shape male

The male face is drawn using the same principles as those for drawing a female face (see pages 32–33).

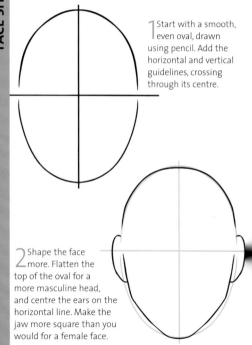

1 Start with a smooth, even oval, drawn using pencil. Add the horizontal and vertical guidelines, crossing through its centre.

2 Shape the face more. Flatten the top of the oval for a more masculine head, and centre the ears on the horizontal line. Make the jaw more square than you would for a female face.

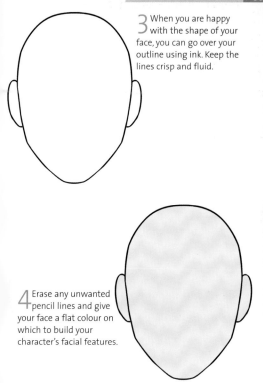

3 When you are happy with the shape of your face, you can go over your outline using ink. Keep the lines crisp and fluid.

4 Erase any unwanted pencil lines and give your face a flat colour on which to build your character's facial features.

basic face shape child

Although the child's face starts with an oval (like the female and male faces on pages 32–35), it is essentially round.

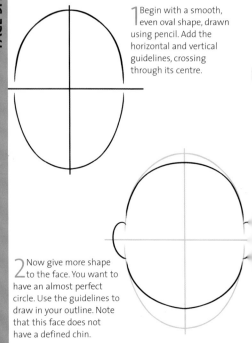

1 Begin with a smooth, even oval shape, drawn using pencil. Add the horizontal and vertical guidelines, crossing through its centre.

2 Now give more shape to the face. You want to have an almost perfect circle. Use the guidelines to draw in your outline. Note that this face does not have a defined chin.

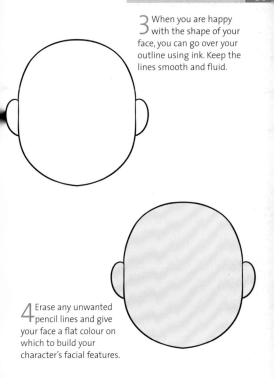

3 When you are happy with the shape of your face, you can go over your outline using ink. Keep the lines smooth and fluid.

4 Erase any unwanted pencil lines and give your face a flat colour on which to build your character's facial features.

looking up and down

You can draw faces looking up or down very easily. It is simply a question of moving the horizontal guideline.

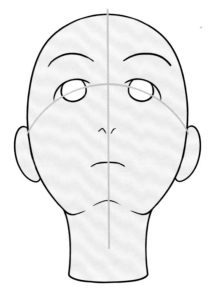

The position of the eyes is always determined by your horizontal guideline. To make a face look up, draw the horizontal guide as a rising curve, and position the ears, so that they hang below this line.

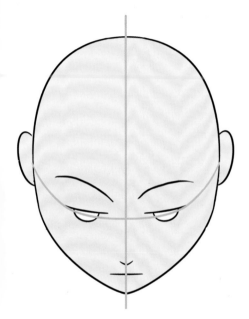

To make a face look down, draw the horizontal guide as a falling curve, and position the ears, so that they sit above this line. Note the shape of the eyes in both drawings – half-closed when looking down.

GALLERY

LEFT A side profile of a manga female, with the head tipped back and eyes closed. The shape of her head is exaggerated.

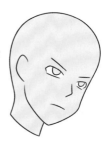

RIGHT A three-quarter view of a manga male with a serious expression. He has youthful rounded cheeks.

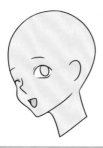

LEFT A three-quarter view of a cheeky manga character, winking with one eye and the mouth slightly open.

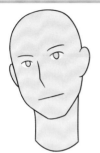

LEFT A straight-on view of a more mature male. He has more human facial features and a square jaw.

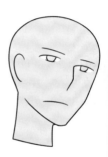

RIGHT A three-quarter view of a male character with human-looking features and an angular jaw.

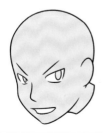

LEFT A three-quarter view of an angry manga character, with expressive eyes and mouth.

eye styles

Manga eyes are wider and taller than human versions. There are also differences between male and female eyes.

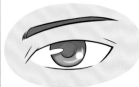

LEFT A realistic male eye. Both the shape and the shading of the eye are similar to those of a human.

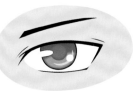

RIGHT A half-realistic male eye, wider than normal, and more angular. This is typical for the more mature male manga.

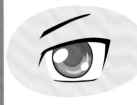

LEFT An exaggerated male manga eye, used for younger characters. The eye is taller and wider, now, with an almost square outline.

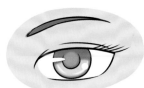

LEFT A half-realistic female eye. The shape of the eye, is softer and more rounded than that of the male, as is the eyebrow.

RIGHT A half-realistic female eye. It is taller than normal, and more rounded. This is used for the adult female manga.

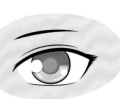

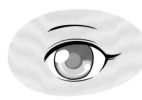

LEFT An exaggerated female manga eye, seen in younger characters. It is taller and wider now – almost a perfect circle in shape.

realistic eye

You may want to create female characters that are close to humans in appearance, with realistic eyes.

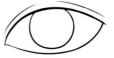

1 For a female eye, start with a pencil outline of the basic shape. Essentially, this is a narrow oval with shaped corners.

2 Draw in the iris shape – it should be partly obscured at the top, where it disappears beneath the upper eyelid. Add a feint outline of the upper lid.

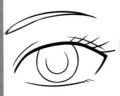

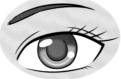

3 Continue to build up your drawing, adding the pupil, an eyebrow and some eyelashes. Go over your outline in ink.

4 Erase any unwanted pencil lines and colour up the eye. Add a few highlights to make it look more realistic.

The process for drawing a realistic male eye is the same as for the female version, left.

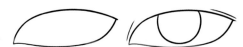

1 Start with a pencil outline of the basic shape. Notice that the male eye is longer and narrower than that of the female.

2 Draw in the iris shape – it will be obscured at the top by the upper eyelid. Draw in a couple feint lines to give the impression of the upper lid.

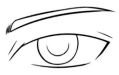

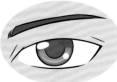

3 Continue to build up your drawing, making the shape more angular in places. Add the pupil and eyebrow, but no eyelashes. Go over your outline in ink.

4 Erase any unwanted pencil lines and colour up the eye. Add a few highlights to make it look more realistic.

half-realistic eyes

This eye shape is typically used for adult female characters. It is fuller and more angular than the realistic version.

1 Start with a pencil outline of the basic shape of the eye. Make your oval shape deeper, and more exaggerated than for the realistic version (see page 44).

2 Draw in the iris shape – it should be partly obscured at the top, where it disappears beneath the upper eyelid. Thicken the top edge of your oval outline and draw in the upper eyelid.

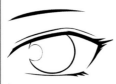

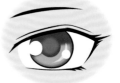

3 Work in some more detail. Make your lines more angular, add any eyebrow and draw in some stylised eyelashes. Go over your outline in ink.

4 Erase any unwanted pencil lines and colour up the eye. Add a few highlights to make it look more realistic.

Narrower than the realistic male eye on pages 45, the half-realistic version is often used for adult characters.

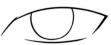

1 Start with a pencil outline of the basic shape of the eye. You do not have to draw a complete outline. Keep it narrow and slightly angled at each corner.

2 Draw in the iris shape – it will be obscured at the top by the upper eyelid.

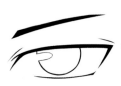

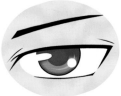

3 Draw in the eyebrow at an angle and add a couple feint lines to suggest the upper eyelid and any highlights. Thicken and square up your outline.

4 Go over your outline in ink and erase any unwanted pencil lines. Colour up the eye, adding a few highlights to make it look more realistic.

manga eyes

This style of eye is mostly used for younger female characters, such as teenagers.

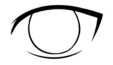

1 Start with a pencil outline of your eye shape – it does not have to be complete. Make it rounder than for the realistic version, and thicken up the lines along the top edge and outer corner.

2 Draw in the iris shape, bearing in mind that it should be obscured at the top by the upper eyelid.

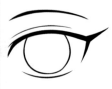

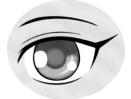

3 Add more detail. Draw in the eyebrow and add a feint line to suggest the upper eyelid. Pull out the out corner of the eye to exaggerate the shape.

4 Go over your outline in ink and erase any unwanted pencil lines. Colour up the eye, adding a few highlights to make it look more realistic.

Squarer than the realistic male eye on pages 45, the manga version is used for teenagers.

1 Start with a pencil outline of your eye shape – it does not have to be complete. Make it almost rectangular in shape, and thicken up the lines along the top and sides.

2 Draw in the iris shape – it will be obscured at the top by the upper eyelid.

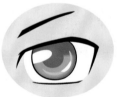

3 Draw in the eyebrow at an angle, but don't do much more. This style of eye is best kept simple.

4 Go over your outline in ink and erase any unwanted pencil lines. Colour up the eye, adding a few highlights to make it look more realistic.

manga eye child

This is the most exaggerated style of manga eye and is used mostly for children and chibis.

1 Begin by drawing the basic shape of the eye. In this case it is almost round. You don't have to draw a complete outline. Make the lines at the top of the eye the thickest.

2 Now draw in the iris. This needs to be an exaggerated form, and should be oval in shape rather than round. Keep the top edge obscured behind the upper eyelid.

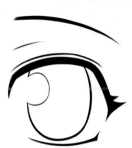

3 Draw in more detail: an arched eyebrow, highlights in the eye and some stylised eyelashes. Add a few feint lines to suggest the upper eyelid.

4 Go over your outline in ink and erase any unwanted pencil lines. Colour up your eye to finish, adding highlights to keep it realistic.

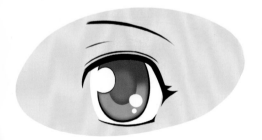

eyes: different angles

In order to draw manga characters in all sorts of situations, you need to be able to draw the eye at different angles.

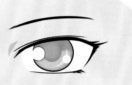

ABOVE The most straightforward angle is face on. You need to draw a mirror image of this (the right eye) on the opposite (left) side of the face.

BELOW This is the eye seen from the side. You only need to draw one eye, as the face is seen in profile.

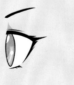

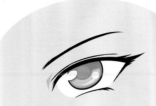

ABOVE This shows how to draw an eye when the character is looking up (see also, page 38). The left eye should look in the same direction.

BELOW This shows how to draw an eye when the character is looking down (see also, page 39). Again, the left eye should look the same way.

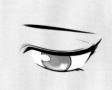

eyes: different expressions

Depending on your story line, your manga characters will need to show a range of different expressions.

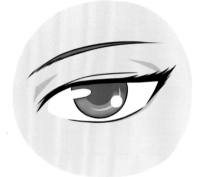

This eye is staring out straight ahead. It needs to be mirrored exactly by the opposite eye for the best effects.

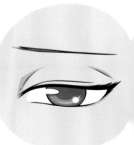

A sad eye. The sadness is conveyed by the heavy upper lid, half-closing the eye, and the straight line of the eyebrow.

A smiling eye. The eye tends to close when we smile – sometimes completely. The lines are soft and sweeping, with very gentle curves.

An angry eye. The shape of the eye narrows dramatically at the inner corner, with the eyebrow flaring above.

A crying eye. This is an exaggerated form of the sad eye opposite, but with tears welling up.

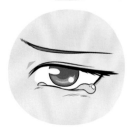

GALLERY

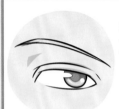

LEFT The staring eye of an adult male, with the eyebrow raised. The eye is realistic, like that of a human being.

RIGHT A young child's eye. It is taller and wider than a regular eye – a manga eye in its most exaggerated form.

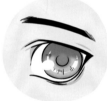

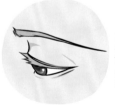

LEFT A three-quarter view of an eye looking down. The colouring of the eyebrow and eyelashes suggest an older manga.

RIGHT An adult male looking to his left. The eye becomes narrower at the at the outer corner of the eye – the direction in which he is looking.

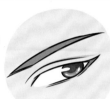

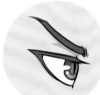

LEFT An eye in side profile. The flaring shape of the eyebrow suggests a meanness in the character.

RIGHT A female eye looking straight on. The shape of the eye is realistic, like that of a human.

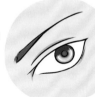

nose styles

Manga noses rarely look as realistic as human ones, but there are still several styles to practise.

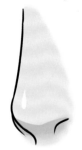

LEFT This half-realistic nose is drawn using lines and just a suggestion of nostrils. Usually just one nostril is shown in this style of nose.

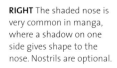

RIGHT The shaded nose is very common in manga, where a shadow on one side gives shape to the nose. Nostrils are optional.

LEFT This is the simplest style, used mostly on young characters. It simply involves one line to show the bottom of the nose. The nostril is optional.

LEFT A typical adult manga nose, seen in profile. The nostril is optional.

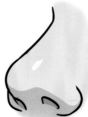

RIGHT A half-realistic nose, seen from below. Because this style is closer to a regular human nose, it works best with nostrils.

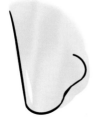

LEFT This is a half-realistic nose seen from above. All that is needed is a simple, fluid outline.

GALLERY

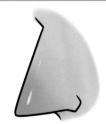

LEFT A very angular nose, seen in profile. This style of nose is often used for evil characters.

RIGHT A typical manga nose, seen in profile. This could be used for a teenager or young adult. It is very small and slightly turned up.

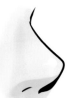

LEFT A nose seen from the three-quarter view. The lines are simple, with the shading to the left of the nose giving it its shape.

RIGHT A nose in profile, and seen slightly from below. The lines are abstract, and shading helps define the shape.

LEFT An angular nose, seen from above. This style of nose is often used for evil characters.

RIGHT A variation of the nose opposite, where the shading is more pronounced, and the nose is slightly less angular.

mouth styles

At times, the manga mouth can be drawn as one simple line.
There are three other styles to practise, too.

1 Apart from the single-line style, this is the simplest kind of mouth, drawn using just two lines to give it shape.

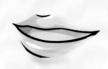

2 This is the half-lip mouth. You start by drawing the simple mouth and then add one or two lines above it. You don't need to draw the full lips.

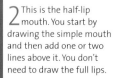

3 This is the full-lipped mouth. Both the top and bottom lips are drawn, quite simply, to give the appearance of a more realistic mouth.

mouths: expressions

Your manga characters will need to show a range of different facial expressions. Practise drawing different mouths.

LEFT A laughing mouth. The corners of the mouth are turned up and just the top row of teeth is visible. There are no lips.

RIGHT A grimace, seen in side profile. The expression is captured by baring all of the character's teeth.

LEFT A simple mouth – an outline with no lips – showing teeth and tongue. The character could be shouting or gasping.

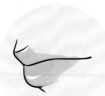

LEFT A closed, full-lipped mouth, seen in profile. This style of mouth gives a serene, pensive expression.

RIGHT A three-quarter view of a full-lipped mouth, teeth just visible. The parted lips suggest that the person is talking.

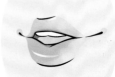

LEFT A simple mouth, open, as if shouting. The teeth and tongue are drawn as outlines. The lips are added using colour and a couple feint lines.

GALLERY

LEFT A simple half-lipped mouth, seen face on. The teeth are visible, and the corners of the mouth turned up in a smile.

RIGHT This is one of the simplest styles of mouth. It is almost just oval-shaped, and suggests that the character is shouting.

LEFT This mouth is all teeth! Seen from the side, this character is grimacing in anger and there are no lips visible at all.

RIGHT A laughing mouth. The mouth is wide open, with all teeth visible.

LEFT Three-quarter view of full-lipped mouth. This style of mouth would suit a more human-looking manga character.

RIGHT A simple half-lip style of mouth, open with a wide smile.

ear styles

Manga ears are tend to be more realistic then other facial features. Simpler versions are used for chibis.

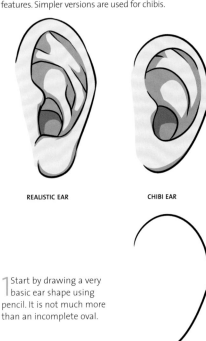

REALISTIC EAR

CHIBI EAR

1 Start by drawing a very basic ear shape using pencil. It is not much more than an incomplete oval.

2 Draw in the inner ear shape, using your basic outline as a guide. Remember to leave room for the ear lobe.

3 Begin to add more detail. You can make this as complex or as simple as you like – it will often depend on your character.

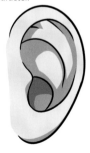

4 Go over your outline in ink and erase unwanted pencil lines. Colour up your ear, adding a few highlights to make it more convincing.

GALLERY

LEFT A less realistic ear, this is small and angular, with a very pointed top.

RIGHT A realistic-looking pierced ear seen from a rear three-quarter view. The back of the ear is just visible.

LEFT A simple ear seen from the rear – just the back of the ear is visible.

RIGHT A realistic ear, seen when looking at a character face on. The ear is foreshortened, to give an idea of perspective.

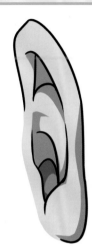

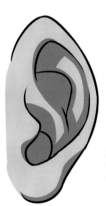

LEFT A realistic ear seen when looking at a character in profile.

constructing a face

Here is a useful grid for drawing a face in proportion, plus a few basic rules to help you get started.

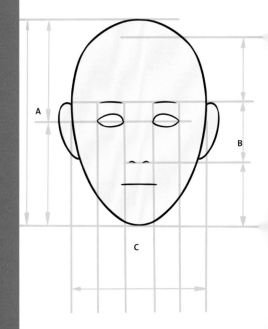

A Divide the face into two halves, horizontally; the eyes and ears will be centred on this line.

B Divide the face into thirds, horizontally. All of the facial features fall in the bottom two-thirds.

C Divide the face into five equal sections, vertically. This will help you to centre the nose, eyes and mouth, so the face is symmetrical.

With these three rules established, you can draw any type of face you want. Manga characters have exaggerated features, especially the eyes, but the principles always remain the same.

young female face

Here are some basic instructions for drawing a young female face. Refer to the basic female face shape on pages 32–33.

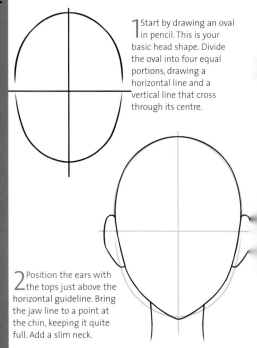

1 Start by drawing an oval in pencil. This is your basic head shape. Divide the oval into four equal portions, drawing a horizontal line and a vertical line that cross through its centre.

2 Position the ears with the tops just above the horizontal guideline. Bring the jaw line to a point at the chin, keeping it quite full. Add a slim neck.

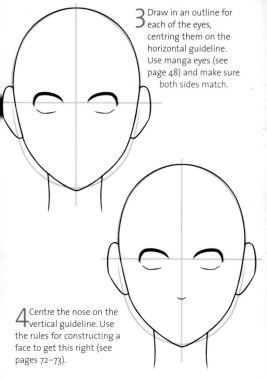

3 Draw in an outline for each of the eyes, centring them on the horizontal guideline. Use manga eyes (see page 48) and make sure both sides match.

4 Centre the nose on the vertical guideline. Use the rules for constructing a face to get this right (see pages 72–73).

▶▶

young female face continued

5 Still using the rules for constructing a face, centre the mouth on the vertical guideline, positioning it between the nose and the chin.

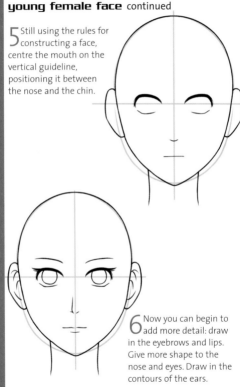

6 Now you can begin to add more detail: draw in the eyebrows and lips. Give more shape to the nose and eyes. Draw in the contours of the ears.

7 Draw in the hair. It should stand proud of your basic outline, to give the impression of volume.

8 Go over your outline in ink and erase unwanted pencil lines. Colour up your image to finish, keeping it simple.

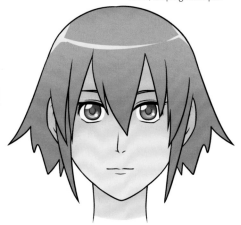

young female face three-quarter view

Here is the same young female as shown on pages 74–77, this time showing how to draw a three-quarter view.

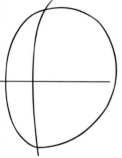

1 Start with a basic oval shape in pencil. This time, tilt it slightly to one side. When drawing in the guidelines, move them slightly off-centre, towards the front of the head.

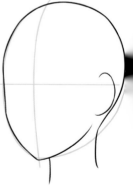

2 Give more shape to the head now, using the curves of the oval to guide you. The ear centres on the horizontal guideline at the back of the head, with the neck coming just below.

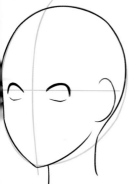

3 Centre the large manga eyes on the horizontal line. They should be equidistant from the vertical line, and the same size as each other.

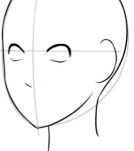

4 Centre the mouth on the vertical line. You can use the rules for constructing a face on pages 72–73 to find the right position.

▶▶

young female face three-quarter view

5 Centre the nose on the vertical line, just above the mouth. Use the rules for constructing a face on pages 72–73 for this.

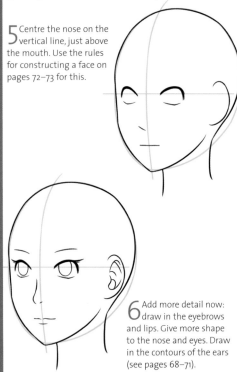

6 Add more detail now: draw in the eyebrows and lips. Give more shape to the nose and eyes. Draw in the contours of the ears (see pages 68–71).

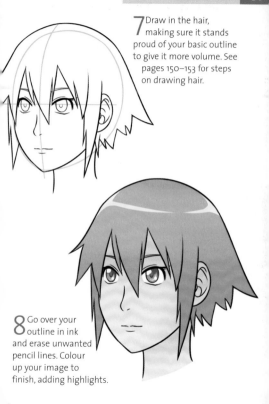

7 Draw in the hair, making sure it stands proud of your basic outline to give it more volume. See pages 150–153 for steps on drawing hair.

8 Go over your outline in ink and erase unwanted pencil lines. Colour up your image to finish, adding highlights.

young female face side view

Here is the same young female as shown on pages 78–81, this time showing how to draw a side view.

1 Using a pencil, draw a basic teardrop shape, point downwards and tilted slightly to one side. You only need a horizontal guideline, halfway down.

2 Give more shape to the head, using the curves of the teardrop to guide you, and draw in the neck. Position the ear on the horizontal line towards the back of the head. Leave a gap for the nose.

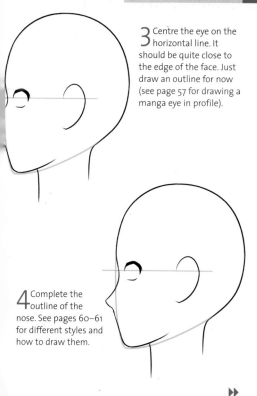

3 Centre the eye on the horizontal line. It should be quite close to the edge of the face. Just draw an outline for now (see page 57 for drawing a manga eye in profile).

4 Complete the outline of the nose. See pages 60–61 for different styles and how to draw them.

▶▶

young female face side view continued

5 Draw in the mouth and lips, just below the nose. See pages 64–65 for different styles and how to draw them.

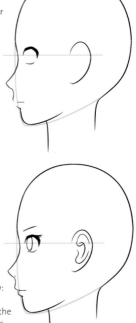

6 Add more detail now: draw in an eyebrow and give more shape to the eye. Draw in the contours of the ear.

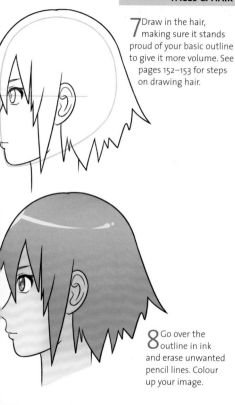

7 Draw in the hair, making sure it stands proud of your basic outline to give it more volume. See pages 152–153 for steps on drawing hair.

8 Go over the outline in ink and erase unwanted pencil lines. Colour up your image.

mature female face

The principles here are the same as those for drawing the young female face, with leaner facial features.

1 Draw an oval shape in pencil. This is your basic head shape. Divide the oval into four equal portions, drawing a horizontal line and a vertical line that cross through its centre.

2 Refine your head shape, making the face slimmer than the one for the young female face on page 32. Position the ears and draw in a slim neck.

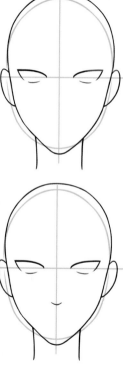

3 See pages 42–43 for different eye shapes; eyes for a mature female are quite narrow. Centre them on the horizontal guideline, making sure both sides match.

4 Centre the nose on the vertical guideline. Use the rules for constructing a face to get this right (see pages 72–73).

▶▶

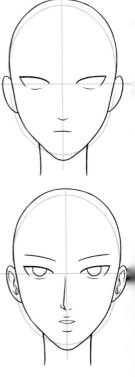

mature female face continued

5 Still using the rules for constructing a face, centre the mouth on the vertical guideline, between the nose and the chin.

6 Now you can begin to add more detail: draw in the eyebrows and lips. Give more shape to the nose and eyes. Draw in the contours of the ears. Keep all of your features lean, using simple lines.

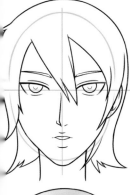

7 Choose a mature hairstyle, making sure it stands proud of your basic outline, to give it some volume. See pages 174–175 for steps on drawing hair.

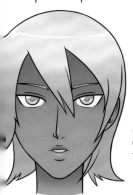

8 Go over your outline in ink and erase unwanted pencil lines. Colour up your image to finish, keeping it simple.

mature female face three-quarter view

Here is the same mature female as shown on pages 86–89, this time showing how to draw a three-quarter view.

1 Start with a basic oval shape in pencil. This time, tilt it slightly to one side. When drawing in the guidelines, move them slightly off-centre, towards the front of the head.

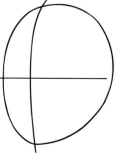

2 Give more shape to the head now, using the curves of the oval to guide you. The ear centres on the horizontal guideline at the back of the head, with the neck coming just below.

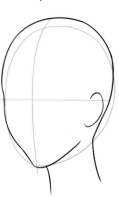

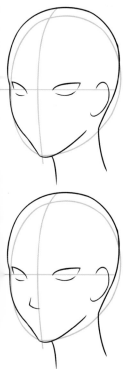

3 Centre narrow manga eyes on the horizontal line. They should be equidistant from the vertical line, and the same size as each other.

4 Centre the nose on the vertical line. You can use the rules for constructing a face on pages 72–73 to find the right position.

▶▶

mature female face three-quarter view

5 Centre the mouth on the vertical line, just above the mouth. Use the rules for constructing a face on pages 72–73.

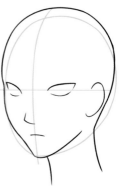

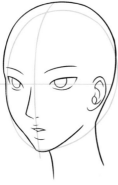

6 Add more detail now: draw in the eyebrows and lips. Give more shape to the nose and eyes. Draw in the contours of the ears (see pages 68–71). Keep the features lean and simple.

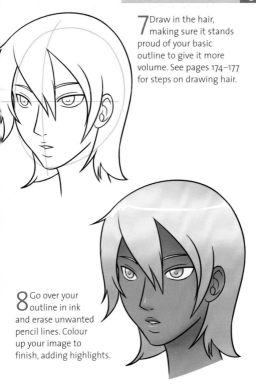

7 Draw in the hair, making sure it stands proud of your basic outline to give it more volume. See pages 174–177 for steps on drawing hair.

8 Go over your outline in ink and erase unwanted pencil lines. Colour up your image to finish, adding highlights.

mature female face side view

Here is the same mature female as shown on pages 86–93, this time showing how to draw a side view.

1 Using a pencil, draw a basic teardrop shape, point downwards and tilted slightly to one side. You only need a horizontal guideline, halfway down. It does not have to reach all the way to the back of the head.

2 Draw a lean-shaped head, using the curves of the teardrop to guide you, and draw in the neck. Position the ear on the horizontal line towards the back of the head. Leave a gap for the nose.

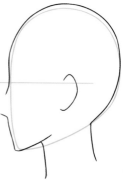

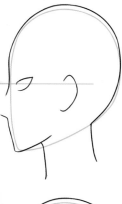

3 Centre an adult manga eye on the horizontal line. It should be quite close to the edge of the face. Just draw an outline for now (see page 57 for drawing an eye in profile).

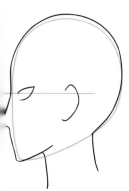

4 Complete the outline of the nose. See pages 58–61 for different styles and how to draw them.

▶▶

mature female face side view continued

5 Draw in the mouth and lips, just below the nose. See pages 62–67 for different styles and how to draw them.

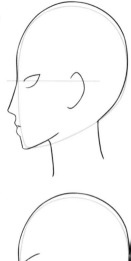

6 Add more detail now: draw in an eyebrow and give more shape to the eye, keeping it narrow and quite angular. Draw in the contours of the ear (see pages 68–71).

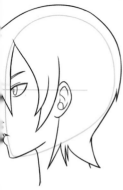

7 Draw in the hair, making it stand proud of your basic outline so that is has volume. See pages 176–177 for steps on drawing hair.

8 Go over the outline in ink and erase unwanted pencil lines. Colour up your image.

young male face

Here are some basic instructions for drawing a young male face. Refer to the basic male face shape on pages 34–35.

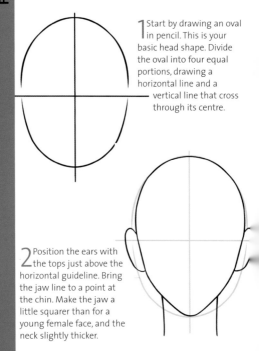

1 Start by drawing an oval in pencil. This is your basic head shape. Divide the oval into four equal portions, drawing a horizontal line and a vertical line that cross through its centre.

2 Position the ears with the tops just above the horizontal guideline. Bring the jaw line to a point at the chin. Make the jaw a little squarer than for a young female face, and the neck slightly thicker.

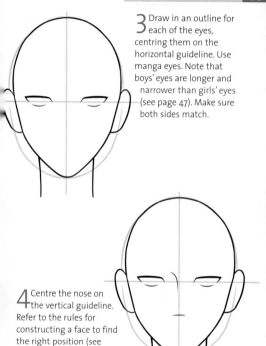

3 Draw in an outline for each of the eyes, centring them on the horizontal guideline. Use manga eyes. Note that boys' eyes are longer and narrower than girls' eyes (see page 47). Make sure both sides match.

4 Centre the nose on the vertical guideline. Refer to the rules for constructing a face to find the right position (see pages 72–73).

▶▶

young male face continued

5 Still using the rules for constructing a face, centre the mouth on the vertical guideline, positioning it between the nose and the chin.

6 Now you can begin to add more detail: draw in the eyebrows and give more shape to the nose and eyes. Draw in the contours of the ears.

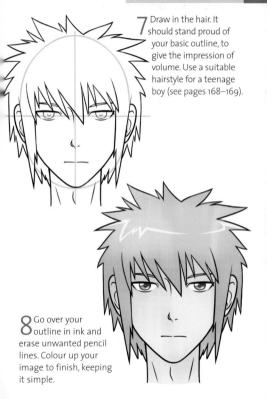

7 Draw in the hair. It should stand proud of your basic outline, to give the impression of volume. Use a suitable hairstyle for a teenage boy (see pages 168–169).

8 Go over your outline in ink and erase unwanted pencil lines. Colour up your image to finish, keeping it simple.

young male face three-quarter view

Here is the same young male as shown on pages 98–101, this time showing how to draw a three-quarter view.

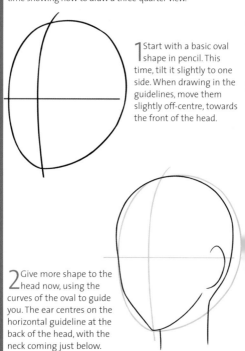

1 Start with a basic oval shape in pencil. This time, tilt it slightly to one side. When drawing in the guidelines, move them slightly off-centre, towards the front of the head.

2 Give more shape to the head now, using the curves of the oval to guide you. The ear centres on the horizontal guideline at the back of the head, with the neck coming just below.

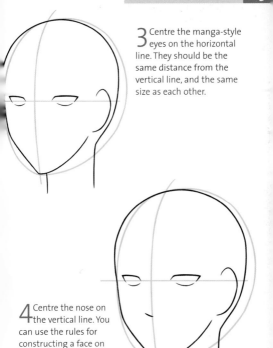

3 Centre the manga-style eyes on the horizontal line. They should be the same distance from the vertical line, and the same size as each other.

4 Centre the nose on the vertical line. You can use the rules for constructing a face on pages 72–73 to find the right position.

▶▶

young male face three-quarter view continued

5 Centre the nose on the vertical line, just above the mouth. Use the rules for constructing a face on pages 72–73 for this.

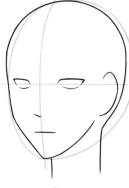

6 Add more detail now: draw in the eyebrows and give more shape to the nose and eyes. Draw in the contours of the ears (see pages 68–71). Give more definition to the neck.

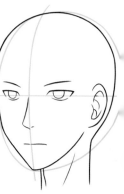

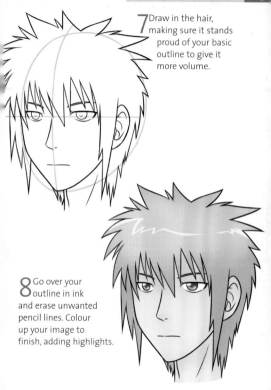

7 Draw in the hair, making sure it stands proud of your basic outline to give it more volume.

8 Go over your outline in ink and erase unwanted pencil lines. Colour up your image to finish, adding highlights.

young male face side view

Here is the same young male as shown on pages 98–105, this time showing how to draw a side view.

1 Using a pencil, draw a basic teardrop shape, point downwards and tilted slightly to one side. You only need a horizontal guideline, halfway down.

2 Give more shape to the head, keeping the jaw line square, and draw in a masculine neck. Place the ear on the horizontal line towards the back of the head. Suggest the nose.

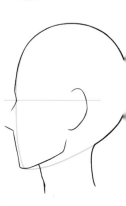

3 Centre the eye on the horizontal line. It should be quite close to the edge of the face. Just draw an outline for now (see page 57 for drawing a manga eye in profile).

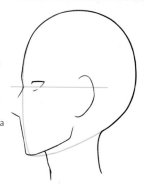

4 Complete the outline of the nose. See pages 58–61 for different styles and how to draw them.

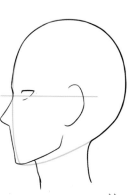

▶▶

young male face side view continued

5 Draw in the mouth, just below the nose, and shape the lips. See pages 62–67 for different styles and how to draw them.

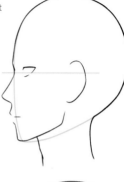

6 Add more detail now: draw in an eyebrow and give more shape to the eye. Draw in the contours of the ear (see pages 68–71).

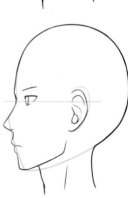

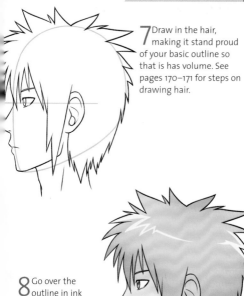

7 Draw in the hair, making it stand proud of your basic outline so that is has volume. See pages 170–171 for steps on drawing hair.

8 Go over the outline in ink and erase unwanted pencil lines. Colour up your image.

mature male face

The principles here are the same as those for drawing the young male face, with more rugged facial features.

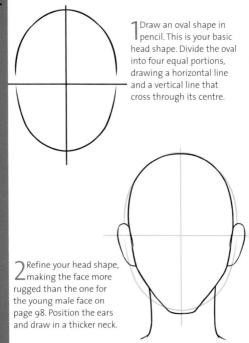

1 Draw an oval shape in pencil. This is your basic head shape. Divide the oval into four equal portions, drawing a horizontal line and a vertical line that cross through its centre.

2 Refine your head shape, making the face more rugged than the one for the young male face on page 98. Position the ears and draw in a thicker neck.

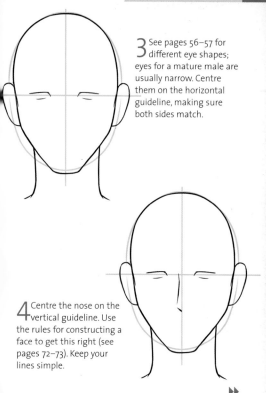

3 See pages 56–57 for different eye shapes; eyes for a mature male are usually narrow. Centre them on the horizontal guideline, making sure both sides match.

4 Centre the nose on the vertical guideline. Use the rules for constructing a face to get this right (see pages 72–73). Keep your lines simple.

▶▶

mature male face continued

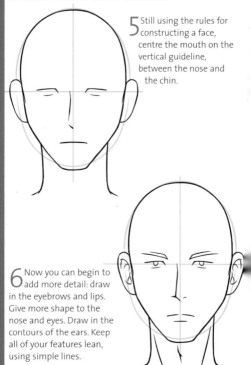

5 Still using the rules for constructing a face, centre the mouth on the vertical guideline, between the nose and the chin.

6 Now you can begin to add more detail: draw in the eyebrows and lips. Give more shape to the nose and eyes. Draw in the contours of the ears. Keep all of your features lean, using simple lines.

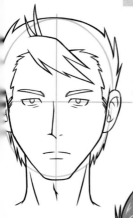

7 Choose a mature hairstyle, making sure it stands proud of your basic outline, to give it some volume. See pages 168–169 for steps on drawing hair.

8 Go over your outline in ink and erase unwanted pencil lines. Colour up your image to finish, keeping it simple.

mature male face three-quarter view

Here is the same mature male as shown on pages 110–113, this time showing how to draw a three-quarter view.

1 Start with a basic oval shape in pencil. This time, tilt it slightly to one side. When drawing in the guidelines, move them slightly off-centre, towards the front of the head.

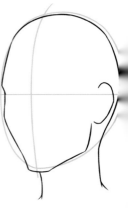

2 Give more shape to the head now. The ear centres on the horizontal guideline at the back of the head, with the neck coming just below. Keep the jaw line rugged.

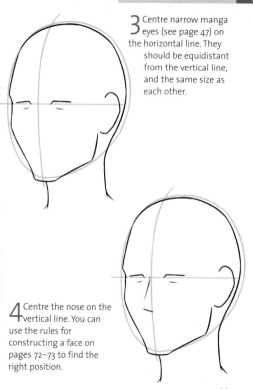

3 Centre narrow manga eyes (see page 47) on the horizontal line. They should be equidistant from the vertical line, and the same size as each other.

4 Centre the nose on the vertical line. You can use the rules for constructing a face on pages 72–73 to find the right position.

▶▶

mature male face three-quarter view

5 Centre the mouth on the vertical line, just below the nose. Use the rules for constructing a face on pages 72–73.

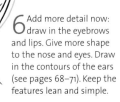

6 Add more detail now: draw in the eyebrows and lips. Give more shape to the nose and eyes. Draw in the contours of the ears (see pages 68–71). Keep the features lean and simple.

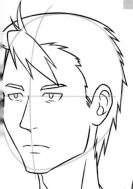

7 Draw in the hair, making sure it stands proud of your basic outline to give it more volume. See pages 168–171 for steps on drawing hair.

8 Go over your outline in ink and erase unwanted pencil lines. Colour up your image to finish, adding highlights.

mature male face side view

Here is the same mature male as shown on pages 114–117, this time showing how to draw a side view.

1 Using a pencil, draw a basic teardrop shape, point downwards and tilted slightly to one side. You only need a horizontal guideline, halfway down. It does not have to reach all the way to the back of the head.

2 Draw a masculine head, using the curves of the teardrop to guide you, and draw in a thicker neck than for a female. Position the ear on the horizontal line towards the back of the head. Suggest the nose.

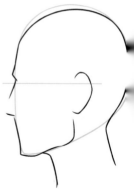

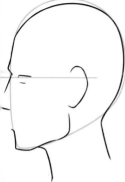

3 Centre an adult manga eye on the horizontal line. It should be quite close to the edge of the face. Just draw an outline for now (see page 57 for drawing an eye in profile).

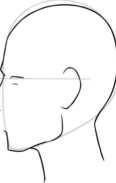

4 Complete the outline of the nose. See pages 58–61 for different styles and how to draw them.

▶▶

mature male face side view continued

5 Draw in the mouth, just below the nose, and give shape to the lips. See pages 62–67 for different styles and how to draw them.

6 Add more detail now: draw in an eyebrow and give more shape to the eye, keeping it narrow and quite angular. Draw in the contours of the ear (see pages 68–71) and some lines to suggests a rugged neck.

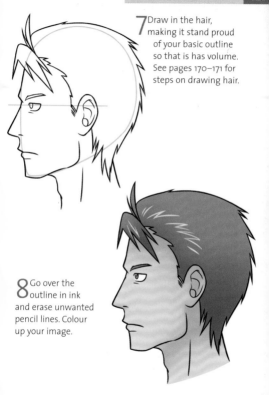

7 Draw in the hair, making it stand proud of your basic outline so that is has volume. See pages 170–171 for steps on drawing hair.

8 Go over the outline in ink and erase unwanted pencil lines. Colour up your image.

child chibi face

Here are some basic instructions for drawing a child chibi face. Refer to the basic child face shape, on pages 36–37.

1 Start by drawing an oval in pencil. This is your basic head shape. Divide the oval into four equal portions, drawing a horizontal line and a vertical line that cross through its centre.

2 Manga children have exaggerated heads. Use your guides to draw an almost perfectly circular head. Position the ears and draw a very slim neck.

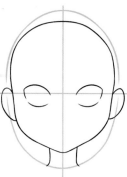

3 Draw in an outline for each of the eyes, centring them on the horizontal guideline. Use child manga eyes (see pages 50–51) and make sure both sides match.

4 Centre the nose on the vertical guideline. It should be very small compared to the eyes. Use the rules for constructing a face to get this right (see pages 72–73).

▶▶

child chibi face continued

5 Still using the rules for constructing a face, centre the mouth on the vertical guideline, placing it between the nose and the chin. Again, it should be small compared to the eyes.

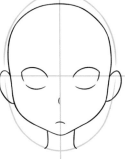

6 Now you can begin to add more detail: draw in the eyebrows and the contours of the ears. Begin to work more detail into the huge eyes.

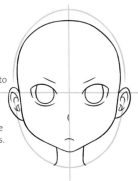

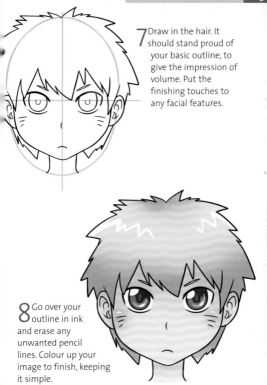

7 Draw in the hair. It should stand proud of your basic outline, to give the impression of volume. Put the finishing touches to any facial features.

8 Go over your outline in ink and erase any unwanted pencil lines. Colour up your image to finish, keeping it simple.

child chibi face three-quarter view

Here is the same child chibi as shown on pages 122–125, this time showing how to draw a three-quarter view.

1 Start with a basic oval shape in pencil. This time, tilt it slightly to one side. When drawing in the guidelines, move them slightly off-centre, towards the front of the head.

2 Give more shape to the head now, using the curves of the oval to guide you. Again, keep the head full, almost round. Draw in a small ear and slim neck.

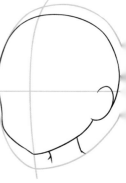

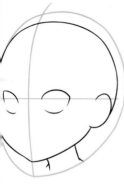

3 Centre the child manga eyes on the horizontal line. They should be equidistant from the vertical line, and the same size as each other.

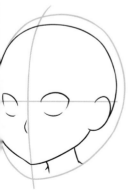

4 Centre the nose on the vertical line. You can use the rules for constructing a face on pages 36–37 to find the right position.

▶▶

child chibi face three-quarter view continued

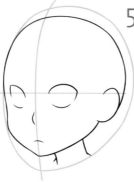

5 Centre the mouth on the vertical line, just below the nose. Follow the rules for constructing a face on pages 72–73 for this. Keep both features small compared to the eyes.

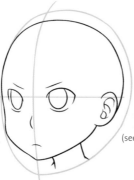

6 Add more detail now: draw in the eyebrows and work more detail into the eyes. Draw in the contours of the ears (see pages 68–71).

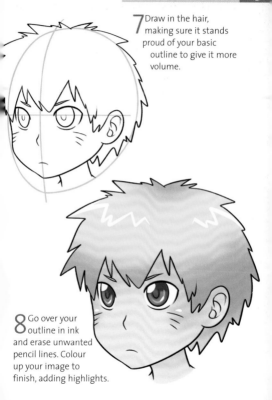

7 Draw in the hair, making sure it stands proud of your basic outline to give it more volume.

8 Go over your outline in ink and erase unwanted pencil lines. Colour up your image to finish, adding highlights.

child chibi face side view

Here is the same child chibi as shown on pages 122–129, this time showing how to draw a side view.

1 Using a pencil, draw a basic teardrop shape, point downwards and tilted slightly to one side. You only need a horizontal guideline, halfway down, and this need not reach to the back of the head.

2 Give more shape to the head, keeping the head large in proportion to the neck. Position the ear on the horizontal line towards the back of the head. Leave a gap for the nose.

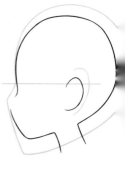

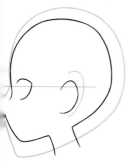

3 Centre the eye on the horizontal line. It should be quite close to the edge of the face and bigger than an adult manga eye. Just draw an outline for now (see page 57 for drawing a manga eye in profile).

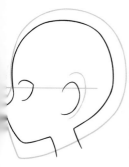

4 Complete the outline of the nose. See pages 58–61 for different styles and how to draw them.

▸▸

child chibi face side view continued

5 Draw in the mouth and lips, just below the nose. See pages 62–67 for different styles and how to draw them.

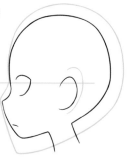

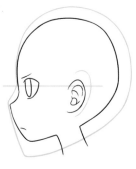

6 Add more detail now: draw in an eyebrow and give more shape to the eye. Draw in the contours of the ear (see pages 68–71).

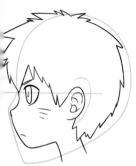

7 Draw in the hair, making sure it stands proud of your basic outline to give it more volume.

8 Go over the outline in ink and erase unwanted pencil lines. Colour up your image.

sad female face

Having mastered drawing different kinds of head, it is good to learn a few basic expressions, such as this sad face.

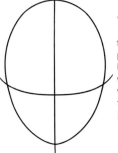

1 Start with a basic outline in pencil, as you would for any female face, see page 22. When drawing the horizontal guideline, do so with a falling curve, as you would when drawing a face looking down (see page 39).

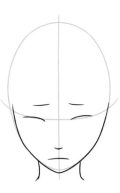

2 Start to draw in the facial features, remembering the rules for constructing a face on pages 72–73. The eyes should sit on the horizontal guideline, either side of the vertical guideline.

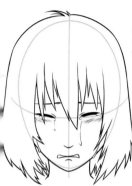

3 Remember that the girl is sad: her eyes are closed and her mouth is unsmiling. Draw in a few tears. Draw an outline for the hair, making it stand proud of your basic guide. The style here hangs close to the face, helping to emphasise the emotion.

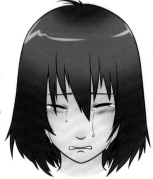

8 Go over your outline in ink and erase unwanted pencil lines. Colour up your image to finish, keeping it simple.

angry male face

Anger can be a difficult emotion to express. Half of the challenge lies in getting the position of the head right.

1 Start with a basic oval, making it slightly larger at the top. This will help with the perspective. When drawing the horizontal guideline, do so with a rising curve, as you would when drawing a face looking up (see page 38).

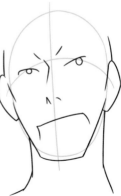

2 Start to draw in the features. Think about the shapes of the man's eyes, mouth and nose as he tips his head back slightly to shout out. Make sure you position the eyes on the horizontal guideline.

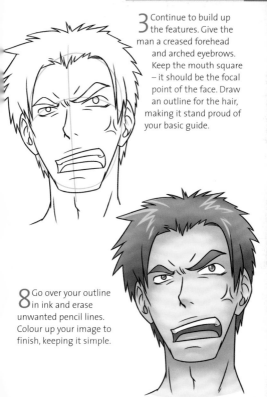

3 Continue to build up the features. Give the man a creased forehead and arched eyebrows. Keep the mouth square – it should be the focal point of the face. Draw an outline for the hair, making it stand proud of your basic guide.

8 Go over your outline in ink and erase unwanted pencil lines. Colour up your image to finish, keeping it simple.

laughing child face

As with many facial expressions, laughter can be seen in all facial features, not just the mouth.

1 Start with a basic oval, making it slightly larger for the fuller head of a manga child. When drawing the horizontal guideline, do so with a rising curve, as you would when drawing a face looking up (see page 38).

2 Position the facial features. This eyes and visible ear should sit on the horizontal guideline. Make sure you keep the mouth big and open.

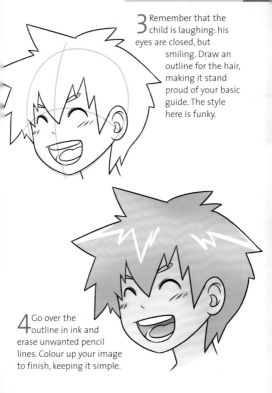

3 Remember that the child is laughing: his eyes are closed, but smiling. Draw an outline for the hair, making it stand proud of your basic guide. The style here is funky.

4 Go over the outline in ink and erase unwanted pencil lines. Colour up your image to finish, keeping it simple.

GALLERY

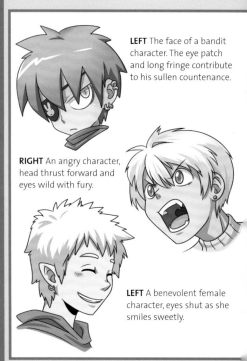

LEFT The face of a bandit character. The eye patch and long fringe contribute to his sullen countenance.

RIGHT An angry character, head thrust forward and eyes wild with fury.

LEFT A benevolent female character, eyes shut as she smiles sweetly.

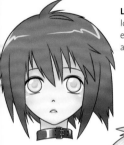

LEFT The forlorn face of a lost chibi. Her pale staring eyes capture the look of abandonment.

RIGHT A character exclaiming in fear. Her eyes betray the anxiety she is feeling.

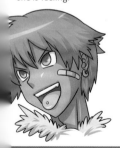

LEFT The taunting face of an evil character. She is laughing, but her eyes are wide open and mean.

hair

There are many different hairstyles available to you for your manga characters — long, short, wavy, spiky, loose, and tied — in an unlimited range of colours. Each of them is shown on the following pages, complete with advice on how to achieve different looks, and how to colour hair and add highlights for an authentic finish.

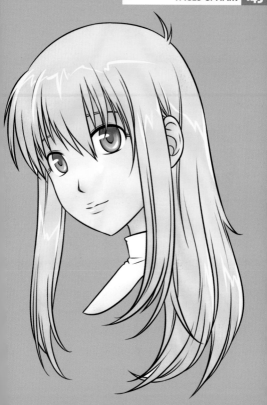

hair types

Depending on the kind of hair that you want to draw, it pays to have a few tips on technique.

Short hair easily looks messy, so give it a good structure. Try to make it look layered, as it is when cut by a hairdresser.

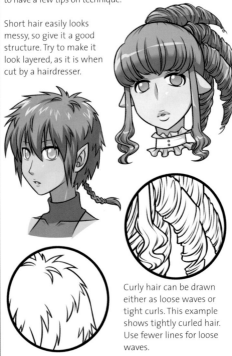

Curly hair can be drawn either as loose waves or tight curls. This example shows tightly curled hair. Use fewer lines for loose waves.

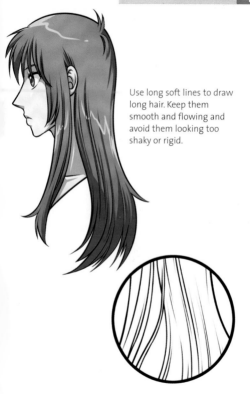

Use long soft lines to draw long hair. Keep them smooth and flowing and avoid them looking too shaky or rigid.

highlights on black hair

In order to make a character's hair look convincing, you need to add tone and highlights.

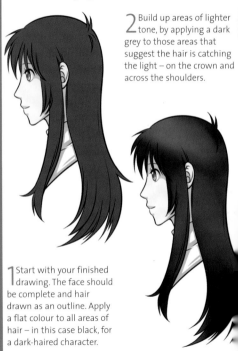

2 Build up areas of lighter tone, by applying a dark grey to those areas that suggest the hair is catching the light – on the crown and across the shoulders.

1 Start with your finished drawing. The face should be complete and hair drawn as an outline. Apply a flat colour to all areas of hair – in this case black, for a dark-haired character.

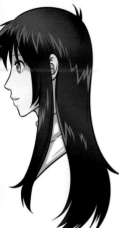

4 Finish off by adding some brilliant white to your highlights. Be sparing however, as it is easy to overdo this stage.

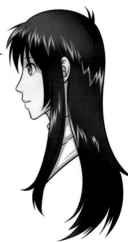

3 Introduce some highlights to emphasise the sheen of the hair. This is usually most evident where the hair follows the curve of the skull and/or shoulders.

highlights on blonde hair

The principles for adding highlights to blonde hair are the same as for black hair, but in reverse.

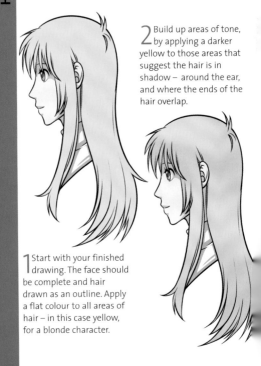

2 Build up areas of tone, by applying a darker yellow to those areas that suggest the hair is in shadow – around the ear, and where the ends of the hair overlap.

1 Start with your finished drawing. The face should be complete and hair drawn as an outline. Apply a flat colour to all areas of hair – in this case yellow, for a blonde character.

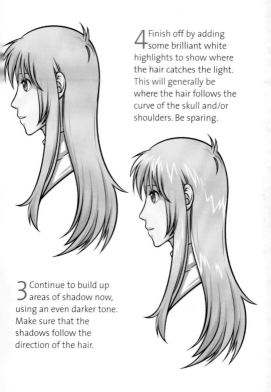

4 Finish off by adding some brilliant white highlights to show where the hair catches the light. This will generally be where the hair follows the curve of the skull and/or shoulders. Be sparing.

3 Continue to build up areas of shadow now, using an even darker tone. Make sure that the shadows follow the direction of the hair.

short hair

You can use the following instructions for giving any manga character short hair.

1 Using pencil, draw a manga child following the instructions on pages 122–125. Keep the eyes as your central focus.

2 Draw a basic outline for the hair. In order to make it look realistic, the hair needs plenty of volume. You can achieve this by making your outline stand proud of the skull.

3 Add a few lines for detail – in the fringe, for example – but keep it simple. Make sure you draw in the hairline as it goes around the back of the head. This will help to make your character look three-dimensional.

4 Go over your outline in ink and erase any unwanted pencil. Colour up your image. When it comes to the hair, build up tone following the instructions for, in this case, dark hair (see pages 146–147).

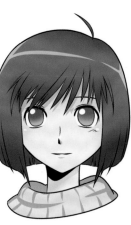

short hair side view

Here is the same girl as shown on pages 150–151, this time showing how to draw her hair from the side.

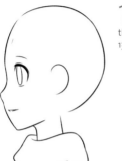

1 Draw a manga child from the side, following the instructions on pages 130–133. Use pencil.

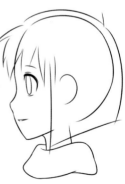

2 Draw a basic outline for the hair, remembering to make the outline stand proud of the skull on top and at the back, in order to make it look realistic.

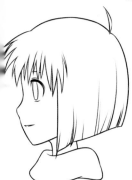

3 Add a few lines for detail – in the fringe and at the base of the hair as it goes around the back of the head, for example – but keep it simple.

4 Go over your outline in ink and erase any unwanted pencil. Colour up your image. When it comes to the hair, build up tone following the instructions for, in this case, dark hair (see pages 146–147).

short hair rear view

Here is the same girl as shown on pages 150–153, this time showing how to draw her hair from the rear.

1 Using pencil, draw a manga child from the rear. This is the same as drawing the child face on, but without having to add any facial features.

2 Draw a basic outline for the hair, remembering to make the outline stand proud of the skull all the way around, in order to make it look realistic.

3 Add a few lines for detail – at the cut edges, for example – but keep it simple. Draw in the hairline as it goes round to the front of the head. This will help to make your character look three-dimensional.

4 Go over your outline in ink and erase any unwanted pencil. Colour up your image. When it comes to the hair, build up tone following the instructions for, in this case, dark hair (see pages 146–147).

long wavy hair

Long wavy hair is most often used for young women and teenage girl characters.

1 Using pencil, draw a manga teenager following the instructions on pages 74–75. Keep the eyes as your central focus.

2 Draw a basic outline for the hair. It is tied at the sides, so should be closer to the skull than usual. Keep your lines simple when drawing the looser hair.

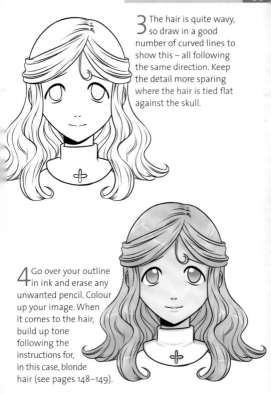

3 The hair is quite wavy, so draw in a good number of curved lines to show this – all following the same direction. Keep the detail more sparing where the hair is tied flat against the skull.

4 Go over your outline in ink and erase any unwanted pencil. Colour up your image. When it comes to the hair, build up following the instructions for, in this case, blonde hair (see pages 148–149).

long wavy hair side view

Here is the same girl as shown on pages 156–157, this time showing how to draw long wavy hair from the side.

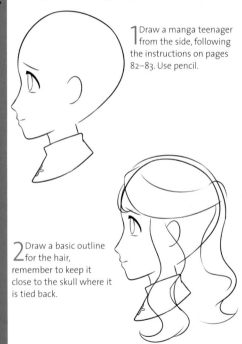

1 Draw a manga teenager from the side, following the instructions on pages 82–83. Use pencil.

2 Draw a basic outline for the hair, remember to keep it close to the skull where it is tied back.

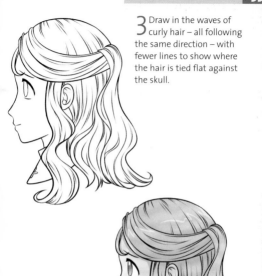

3 Draw in the waves of curly hair – all following the same direction – with fewer lines to show where the hair is tied flat against the skull.

4 Go over your outline in ink and erase any unwanted pencil. Colour up your image. When it comes to the hair, build up tone following the instructions for, in this case, blonde hair (see pages 148–149).

long wavy hair **rear view**

Here is the same girl as shown on pages 158–159, this time
showing how to draw long wavy hair from the rear.

1 Using pencil, draw a
manga teenager from
the rear. This is the same as
drawing the teenager face
on, but without having to
add any facial features.

2 Draw the outline of the
hair, remembering to
keep it close to the skull
where it is tied. Keep
your lines simple for
now. Draw in the
outline of
the hair tie.

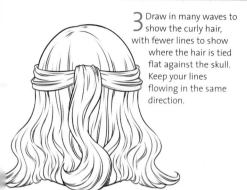

3 Draw in many waves to show the curly hair, with fewer lines to show where the hair is tied flat against the skull. Keep your lines flowing in the same direction.

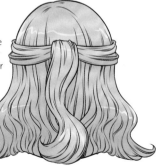

4 Go over your outline in ink and erase any unwanted pencil. Colour up your image. When it comes to the hair, build up tone following the instructions for, in this case, blonde hair (see pages 148–149).

ponytail

This hairstyle combines the straight short hair of the girl on pages 150–151, with a ponytail.

1 Using pencil, draw a manga teenager following the instructions on pages 74–75. Keep the eyes as your central focus.

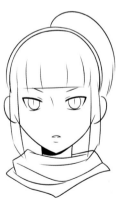

2 Draw a basic outline for the hair. The fringe part of the hair should be close to the skull, because it is tied back. Show the outline of the ponytail sticking up at the back.

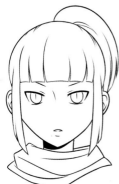

3 Add a few lines for detail – in the fringe, for example – but keep it simple. Add some detail to the ponytail, too. This will help make your character look three-dimensional.

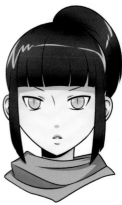

4 Go over your outline in ink and erase any unwanted pencil. Colour up your image. When it comes to the hair, build up tone following the instructions for, in this case, dark hair (see pages 146–147).

ponytail side view

Here is the same girl as shown on pages 162–163, this time showing how to draw a ponytail from the side.

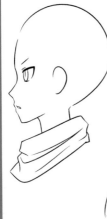

1 Draw a manga teenager from the side, following the instructions on pages 84–85. Use pencil. You can afford to exaggerate the shape of the skull at the back, as this will give the hair more volume.

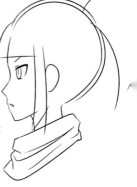

2 Draw a basic outline for the hair, remembering to keep it close to the skull where it is tied back.

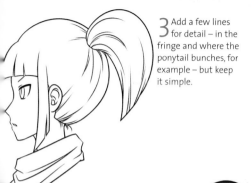

3 Add a few lines for detail – in the fringe and where the ponytail bunches, for example – but keep it simple.

4 Go over your outline in ink and erase any unwanted pencil. Colour up your image. When it comes to the hair, build up tone following the instructions for, in this case, dark hair (see pages 146–147).

ponytail rear view

Here is the same girl as shown on pages 164–165, this time showing how to draw a ponytail from the rear.

1 Using pencil, draw a manga teenager from the rear. This is the same as drawing the character face on, but without having to add any facial features.

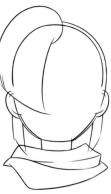

2 Draw a basic outline for the hair, remembering to keep it close to the head. Draw in the ponytail – keeping it in perspective – and the loose hair that falls either side of the girl's face.

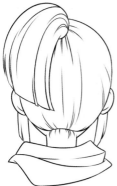

3 Add a few lines in the hair to show how it bunches, and at the cut edges to give the impression of individual hairs.

4 Go over your outline in ink and erase any unwanted pencil. Colour up your image. When it comes to the hair, build up tone following the instructions for, in this case, dark hair (see pages 146–147).

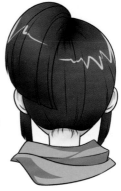

short spiky hair

Short spiky hair is a popular style for many manga characters and is used for both males and females.

1 Using pencil, draw a young male adult following the instructions on pages 98-101.

2 Draw a basic outline for the hair, making it stand proud of the skull. Draw a spiky fringe across the forehead.

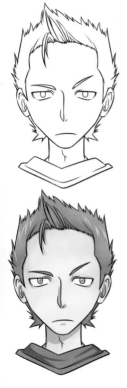

3 Give your outline a spiky edge. Draw in some hair below the ears to show how the hair continues around the back of the head. This will help to make your character look three-dimensional.

4 Go over your outline in ink and erase any unwanted pencil. Colour up your image. When it comes to the hair, build up tone following the instructions for, in this case, dark hair (see pages 146–147).

short spiky hair side view

Here is the same man as shown on pages 168–169, this time showing how to draw his hair from the side.

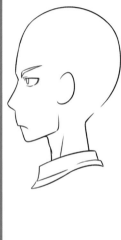

1 Draw a young adult male from the side, following the instructions on pages 106–109. Use pencil to start with.

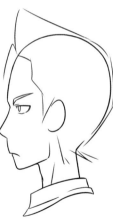

2 Draw a basic outline for his hair. His hair is close cropped at the back and sides, so should sit close to the skull. Make it stand proud of the forehead, however, to make way for the spikes.

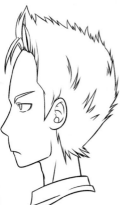

3 Give your outline a spiky edge and add a few lines for detail – in the fringe and above the ears, for example – but try and keep it simple.

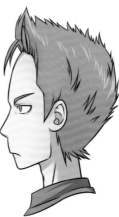

4 Go over your outline in ink and erase any unwanted pencil. Colour up your image. When it comes to the hair, build up tone following the instructions for, in this case, dark hair (see pages 146–147).

short spiky hair rear view

Here is the same man as shown on pages 168–171, this time showing how to draw spiky hair from the rear.

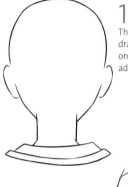

1 Using pencil, draw an adult male from the rear. This is the same as drawing the character face on, but without having to add any facial features.

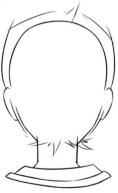

2 Draw a basic outline for the hair, remembering to keep it fuller on the top than at the sides.

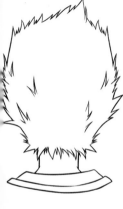

3 Give your outline a spiky edge and add a few spikes in the hair at the back of the head to make it look more three-dimensional.

4 Go over your outline in ink and erase any unwanted pencil. Colour up your image. When it comes to the hair, build up tone following the instructions for, in this case, dark hair (see pages 146–147).

emo hair

Emo hair is a style that hugs the face. As such, it is often long and lank with an asymmetrical fringe.

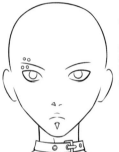

1 Using pencil, draw a young female adult, add in some fashion accessories such as a leather neck collar and eyebrow studs.

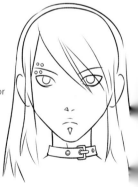

2 Draw a basic outline for the hair. Because it is quite lank, it does not stand too proud of the skull. Draw tresses of different lengths.

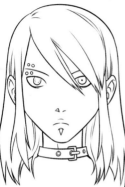

3 Emo hair is always straight. Draw in a few lines to show individual tresses here and there, but keep it simple.

4 Go over your outline in ink and erase any unwanted pencil. Emo hair is often two-tone, so follow instructions for blonde and dark hair when it comes to tone and highlights.

emo hair side view

Here is the same character as shown on pages 174–175, this time showing how to draw her hair from the side.

1 Draw a young adult female from the side. Use pencil. Emo characters tend to be quite skinny, so keep the features lean.

2 Draw a basic outline for the hair. Follow the shape of the skull quite closely. Draw tresses of different lengths.

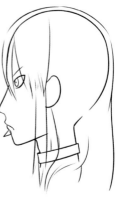

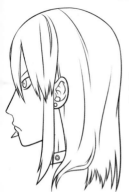

3 Draw in a few lines to show individual tresses here and there, but keep it simple. Bring the fringe right down so that it falls over the left eye.

4 Go over your outline in ink and erase any unwanted pencil lines. Keep the colour reasonably flat, following instructions for both blonde and dark hair when it comes to tone and highlights (see pages 146–149).

emo hair rear view

Here is the same character as shown on pages 174–177, this time showing how to draw emo hair from the rear.

1 Using pencil, draw an adult female from the rear. This is the same as drawing the character face on, but without having to add any facial features.

2 Draw a basic outline for the hair, remembering to keep it close to the skull on the top and over the ears. Make sure the length at the back is uneven along the bottom.

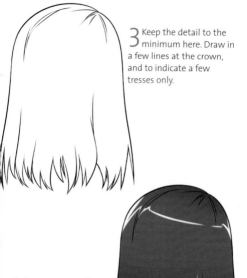

3 Keep the detail to the minimum here. Draw in a few lines at the crown, and to indicate a few tresses only.

4 Go over your outline in ink and erase any unwanted pencil lines. Keep the colour flat, with just a few brilliant white highlights to show where the hair catches the light (see page 147).

soft curly hair

Soft curly hair is often used for young, childlike characters, and is good for both girls and boys.

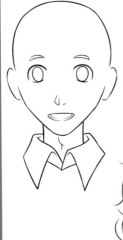

1 Using pencil, draw a manga boy following the instructions on pages 122–125. Keep the eyes as your central focus.

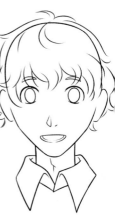

2 Draw a basic outline for the hair. It falls loosely over the forehead. Give it some volume by making it stand proud of the skull.

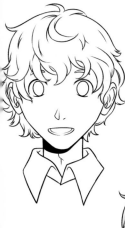

3 The hair is quite curly, so draw in a good number of curved lines to show this. Because the hair is curly rather than wavy, the lines can go in different directions here and there.

4 Go over your outline in ink and erase any unwanted pencil. Colour up your image. When it comes to the hair, build up tone following the instructions for, in this case, blonde hair (see pages 148–149).

soft curly hair side view

Here is the same boy as shown on pages 180–181, this time showing how to draw soft curly hair from the side.

1 Draw a manga boy from the side, following the instructions on pages 130–133. Use pencil.

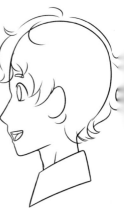

2 Draw a basic outline for the hair, keeping it fairly loose. Give it some volume by making it stand proud of the skull.

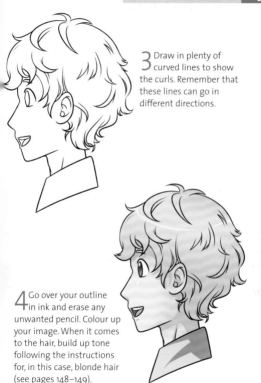

3 Draw in plenty of curved lines to show the curls. Remember that these lines can go in different directions.

4 Go over your outline in ink and erase any unwanted pencil. Colour up your image. When it comes to the hair, build up tone following the instructions for, in this case, blonde hair (see pages 148–149).

soft curly hair rear view

Here is the same boy as shown on pages 182–183, this time showing how to draw soft curly hair from the rear.

1 Using pencil, draw a manga child from the rear. This is the same as drawing the child face on, but without having to add any facial features.

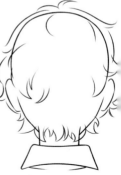

2 Draw a basic outline for the hair, remembering to keep it fairly loose. Give it some volume by making the pencil lines stand proud of the skull.

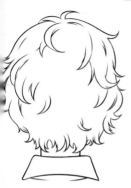

3 Draw in plenty of curved lines going in different directions. This will help to keep the look three-dimensional.

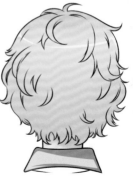

4 Go over your outline in ink and erase any unwanted pencil. Colour up your image. When it comes to the hair, build up tone following the instructions for, in this case, blonde hair.

GALLERY

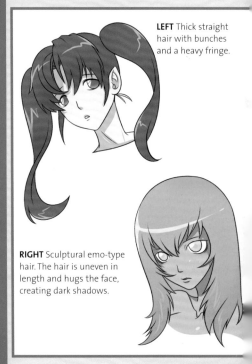

LEFT Thick straight hair with bunches and a heavy fringe.

RIGHT Sculptural emo-type hair. The hair is uneven in length and hugs the face, creating dark shadows.

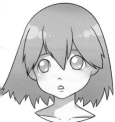

LEFT Short straight hair. The heavy fringe and hair at the back work best if they are of uneven lengths.

RIGHT Heavily textured blonde hair, tied at the back of the head.

LEFT Shaggy, slightly wavy blue hair with high bunches, and an asymmetrical fringe.

GALLERY

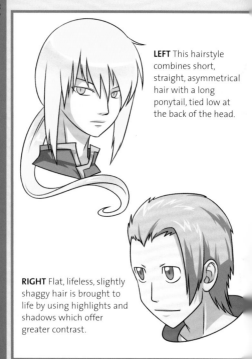

LEFT This hairstyle combines short, straight, asymmetrical hair with a long ponytail, tied low at the back of the head.

RIGHT Flat, lifeless, slightly shaggy hair is brought to life by using highlights and shadows which offer greater contrast.

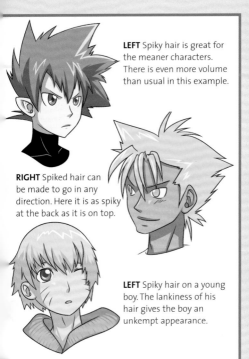

LEFT Spiky hair is great for the meaner characters. There is even more volume than usual in this example.

RIGHT Spiked hair can be made to go in any direction. Here it is as spiky at the back as it is on top.

LEFT Spiky hair on a young boy. The lankiness of his hair gives the boy an unkempt appearance.

index

▶▶

index